"IN THE FUTURE EVERYBODY WILL BE WORLD FAMOUS FOR FIFTEEN MINUTES."

ANDY WARHOL

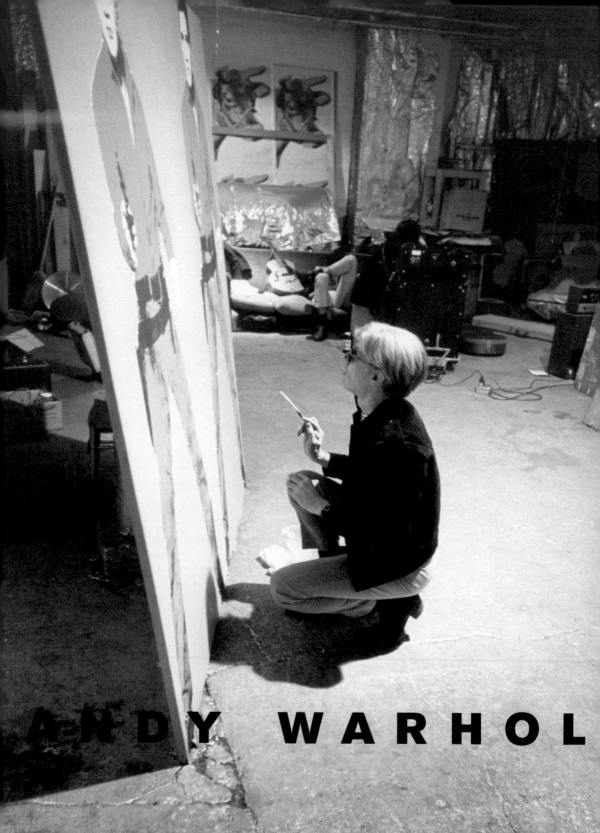

ANDY WARHOL

BELLAGIO GALLERY OF FINE ART, LAS VEGAS

CELEBRITIES
MORE THAN FIFTEEN MINUTES

PAPER
BALL

Published on the occasion of the exhibition

ANDY WARHOL
THE CELEBRITY PORTRAITS

Works from the Mugrabi Collection

Bellagio Gallery of Fine Art, Las Vegas
February 7–September 7, 2003

Library of Congress Control Number: 2002115446
ISBN: 1-931738-04-1

Design: Tomo Makiura
Project editor: Laura L. Morris
Production: Paul Pollard
Printer: Sfera International, Milan

Frontispiece: Nat Finkelstein, *Andy Warhol at
the Factory, New York*, c.1966. © 2003 Nat Finkelstein

Printed in Italy

Andy Warhol: The Celebrity Portraits and this publication would not be possible without the generosity and foresight of the Mugrabi family. Long before the public recognized the pivotal role Warhol played in the history of the twentieth century, José Mugrabi set out to create what would become the world's most comprehensive private collection of the artist's work. A portion of that collection serves as the basis for this exhibition, which was proposed to us by José's son, Alberto Mugrabi. It is thanks to Alberto's tireless help that we have been able to present this exhibition.

Special thanks to our other lenders: Ann and Richard Solomon, New York, and Thomas Sokolowski, Director of The Andy Warhol Museum, Pittsburgh.

We are indebted to the following people for their professional advice and assistance, as well as their time: Esty Neuman, Thomas and Charles Danzinger, and Dr. Theodore Feder.

We also wish to thank our partner, Clear Channel Exhibitions, for its collaboration and support. Our appreciation is also offered to all the staff members of PaperBall and the Bellagio Gallery of Fine Art.

We are grateful to our friends Ingrid Sischy, Editor in Chief of *Interview* magazine, and Sandra Brant, Publisher of *Interview* and Brant Publications, who, as always, have generously offered their help and wisdom. Warm thanks are also extended to Vincent Fremont, who supported the idea for the exhibition from the very beginning.

Acknowledgment is also due to the celebrities Warhol knew and immortalized in art, who by the very nature of their status in our culture gave the artist a never-ending source of inspiration for his work and life. They will continue to entertain generations. Finally, we are especially indebted to Liza Minnelli, one of Andy Warhol's closest friends. Ms. Minnelli kindly agreed to narrate the exhibition's audio guide, for which we are most grateful.

Andrea Bundonis
President, Bellagio Gallery of Fine Art

Marc Glimcher
Chairman, Bellagio Gallery of Fine Art

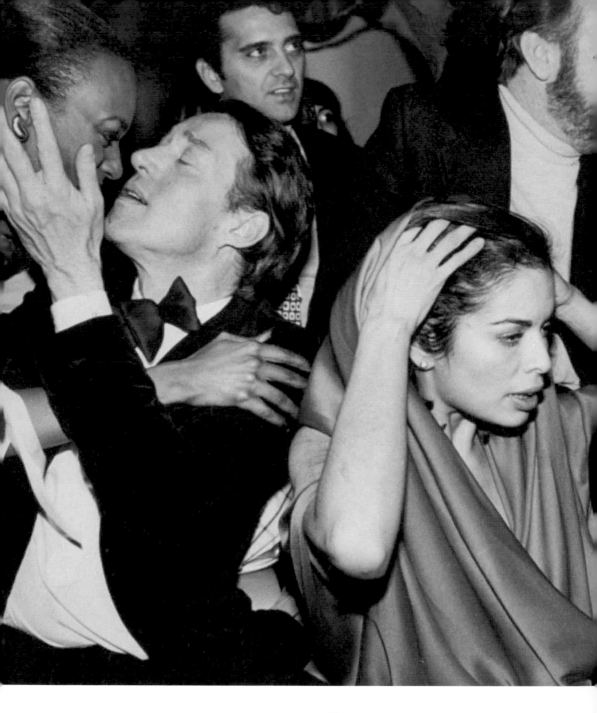

MORE THAN FIFTEEN MINUTES
THE PARADOX OF ANDY WARHOL

Laura L. Morris

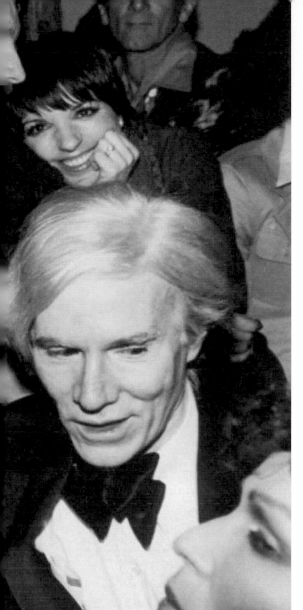

Robin Platzer, *Celebrities (Halston, Bianca Jagger, Andy Warhol, Jack Haley, Jr., Liza Minnelli, and Others) at a New Year's Eve Party at Studio 54, New York*, 1978

Imagine we are out in New York in the late 1970s. It is a Friday night, or maybe even a Monday night. It doesn't matter. Andy Warhol is out every night, a victim of what he calls "Social Disease." As we wait in line to get into the hottest hot spot, Studio 54, at the peak of the disco years, Warhol and his entourage pass by, gaining entrée into the inner sanctum. There he goes, with perhaps Halston, Bianca Jagger, Elizabeth Taylor, Debbie Harry, or a throng of socialites by his side. We, however, are destined to remain behind the cordon, never able to pass muster with the doorman. Andy got it right when he said, at Studio 54, "It's a dictatorship at the door and a democracy on the floor. It's hard to get in, but once you're in you could end up dancing with Liza Minnelli."[1] And in some way, this statement is suggestive of Warhol's life and approach to art. Pale, slightly built, and painfully shy, Warhol had sought to transcend his working-class, immigrant roots. Through his diligence, artistic talent, and promotional skills, he became a phenomenon. Night after night, he was out among the Beautiful People. The party, wherever it happened to be that night, didn't start until Warhol arrived, wearing a mop of a wig and wielding a camera as an ever-present security blanket.

Andy's look is unmistakable, and his art instantly recognizable. Surely the best known of American Pop artists, Warhol gained entry to the world of glamour and celebrity in part through his diverse and unique achievements as an artist. His paintings, drawings, and silkscreens of commercial products and comic strips initially shocked the public and the American art world. However, his deadpan depictions of American staples from Campbell's Soup cans to Coca Cola bottles would become enormously popular.

In the 1940s and 1950s, American painters had been producing huge, abstract paintings, which many critics interpreted as the emotionally wrought, personal expressions of geniuses working in isolation. But as the drip paintings of Jackson Pollock, full of active line, and the vast fields of solid color created by Mark Rothko and others became entrenched in the art scene, popular culture was playing a bigger part in the lives of Americans. In the postwar period, television, Hollywood movies, mass magazines, and comics attracted a middle-class public, many of whom had new leisure time and disposable income on hand as never before. Consumer products and the appeals of advertising were becoming the common stock of American culture.

Warhol was keenly attuned to this shift in the American psyche. Beginning his career as a commercial illustrator, he was well positioned to blur the boundaries between contemporary advertising, popular culture, and highbrow art. After changing his focus in the early 1960s from applied to fine art (and soon thereafter to experimental film), Warhol quickly made the abstractions of the New York School painters seem old-fashioned. Simultaneously, he was able to use his status as a fine artist to gain access to the world of fame and glamour that had fascinated him since childhood. As art historian Robert Rosenblum has remarked, "Warhol's upward mobility was supersonic."[2]

Known for his insecurities, Warhol fashioned a self-effacing, meek public presence, which, paradoxically, both deflected attention away from himself and drew others to him. During the heady 1960s, his studio, nicknamed the Factory, attracted a constantly changing crowd of young wanna-bes. As they became part of his entourage and appeared in his underground films, Warhol transformed them into "superstars," who became cult figures. Warhol was at the center of a bustling beehive of social and creative activity, with assistants helping to make art, organize films, and arrange new portrait commissions.

Mystery, it seems, is irresistible, and Warhol made sure he was known as a man of fascinating contrasts. Behind his self-deprecating facade lay an enormously creative talent that sought constant expression. Craving and winning the spotlight, Warhol was consumed by discomfort about his looks. His statements to journalists and friends, while often amusing and insightful, were usually misleading, if not outright lies. Although he claimed, "I think somebody should be able to do all my paintings for me,"[3] Warhol is described as a workaholic by everyone who knew him. While his own standard replies to journalists consisted of one word, "Ummm" or the more expressive "Wow," Warhol founded a magazine devoted to celebrity interviews.

Although he was deeply insecure, he was able to entice visitors to drop their pants, so he could draw their genitals, or even to get them to engage in sexual acts for his movie camera. All the while, Warhol was living with his mother and some twenty cats, which reportedly reproduced as fast as the kittens could be given away.

• • • •

This curious figure was born Andrew Warhola in Pittsburgh in 1928, the third child of poor immigrants from Czechoslovakia. His father worked in the coal mines and later in construction. His mother looked after their three boys. She went door-to-door peddling her homemade crafts, like crepe-paper flowers, during the leanest years of the Great Depression, and took on occasional house-cleaning jobs in the late 1930s. At around age nine, Warhol was struck by Sydenham's chorea, a disorder of the nervous system causing uncontrollable muscle spasms. During the many hours he spent sick at home under the care of his mother, he drew, colored, and added to his collection of movie-star photographs. The first autographed picture he had received, from child star Shirley Temple, was a treasured possession. He also spent hours pouring through illustrated fan magazines and comic books. Precocious academically, Warhol finished high school at age sixteen. Whereas Andy's two older brothers went to work after their father's death in 1942, their mother encouraged Andy's artistic abilities. Warhol was able to go to college with the family's savings. He attended Pittsburgh's Carnegie Institute of Technology, where he majored in Pictorial Design. Before leaving college, he had already developed a drawing style that was instantly recognized by other students and the faculty.

Warhol would follow the typical rags-to-riches path of the American dream in his own fashion. His immigrant background and the years spent in poverty are often said to have inspired his craving for glamour and the limelight.

More specifically, it was Warhol's early fascination with Hollywood celebrities paired with his attraction to strong graphic images that impelled him in his desire to become a celebrity/artist. He seems to have intuitively understood the power of images to make an impact upon people. In the postwar United States, a receptive public began to be bombarded with images—in the form of movie posters, publicity photos, mass magazines, advertisements, and television. The entertainment industry could create stars by sending their images out into the world over and over again. Even Warhol was not immune to the allure of images. His much-discussed crush on Truman Capote, for example, was sparked by the author's photograph on the back of his 1948 book *Other Voices, Other Rooms*. (The two became friends in the 1970s, although Warhol had practically stalked Capote in New York in the early 1950s.)

After graduation in 1949, Warhol took the bold step of escaping then-gritty Pittsburgh to find his way in New York. Particularly for someone supposedly so unsure of himself, Warhol was bold in calling upon advertising and art directors, portfolio in hand. Through the strength of his drawing, he landed an illustration assignment for *Glamour* magazine within his first week of pounding the pavement. Appropriately, his first professional illustrations accompanied an article titled "Success Is a Job in New York." (In crediting Warhol, the magazine erroneously dropped the a off the end of Warhola. He decided to stick with it, and began using Andy instead of Andrew the next year.) Freelance assignments for such magazines as *Vogue, Seventeen, Harper's Bazaar, Ladies' Home Journal*, and *The New Yorker* followed, and he quickly developed a specialty in illustrating ladies' shoes and accessories. In his customary self-effacing manner, Warhol later reported that he had played upon the sympathy of art directors, particularly women, by speaking in a humble, sheepish manner. Andy also designed window displays for the upscale department stores Bergdorf Goodman and Bonwit Teller, as well as Tiffany & Co. jewelers. When Andy's mother came to New York for a visit in 1952, she decided he needed looking after. She sold the family house and moved in with him that summer.

According to friends, Warhol was aggressive in seeking out new work.[4] As a result, his illustration career blossomed so fruitfully that, in 1955, he hired two assistants to help him fulfill his many assignments. He often did the line drawings and had others fill in the outlines with watercolors. By the late 1950s Warhol had a very successful commercial career under way and had won several awards from the major professional organizations in his field: the Art Directors Club and the American Institute of Graphic Arts.

At this point, although he would maintain his illustration work into 1963 if not longer,[5] Andy decided to concentrate on fine art. He had been making efforts to promote his non-commercial work, and had mounted a few gallery shows of his drawings in the 1950s. In addition, one of his drawings of shoes was included in an exhibition at the Museum of Modern Art, New York, in 1956. Warhol's early paintings, with loose brushwork in acrylic paint on canvas, were inspired by comic strips and advertisements. Soon, however, he decided to pursue a cleaner style and adopted a technique from commercial graphic art: the silkscreen. This decision would prove revolutionary.

Commercial printers would make a silkscreen print by affixing a hand- or machine-cut stencil onto a flat screen (originally made from silk), which had already been stretched on a wood frame. The holes in the stencil allowed ink to be selectively transferred, with a squeegee, through the screen onto paper or fabric. The screen, of course, could be used over and over again to produce numerous, virtually identical images. Warhol would go on to use this technique for works on canvas and on paper.

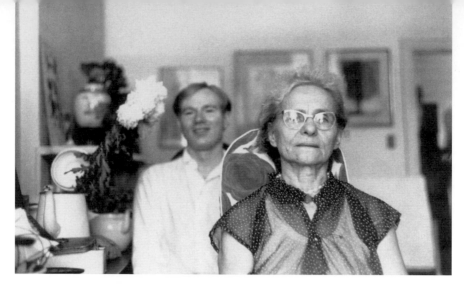

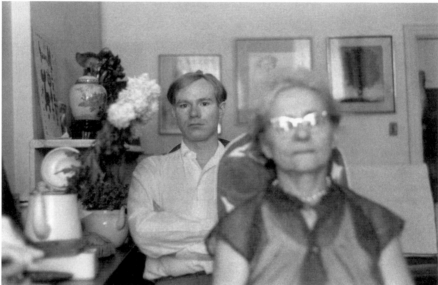

Duane Michals, *Andy Warhol and His Mother Julia Warhola*, 1958

Warhol's earliest silkscreens are based on "found images" rather than his original photographs. Among his sources were glossy prints of movie stars, news photographs of car accidents and an electric chair, and brand-name package designs. These borrowed images were rephotographed so they could be enlarged and converted into silkscreen stencils by a commercial shop. Warhol used halftone dots in these screens—the technique used by newspaper and magazine publishers to produce the appearance of continuous-tone black-and-white photographs with a single black ink. Many different grays are created visually by varying the size and density of the dots to be printed in black.

Of his new method for making paintings, implemented from 1962 on, he remarked: "I tried doing them by hand, but I find it easier to use a screen. This way, I don't have to work on my objects at all. One of my assistants or anyone else, for that matter, can reproduce the design as well as I could."[6] Although his assistant Gerard Malanga helped with the silkscreen paintings, Andy remained involved in every aspect of their production. (Indeed, the size of many of his works demanded that two people handle the mounted screens.) Warhol also claimed: "The reason I'm painting this way is because I want to be a machine. Whatever I do, and do machinelike, is because, it is what I want to do. I think it would be terrific if everybody

was alike."[7] For Andy the silkscreen process was a way to make paintings faster, and, equally importantly, to repeat the same motif again and again, either within a single canvas or on several different ones.

Warhol's reference to mass reproduction and manufacturing—accomplished with the repetition of images in his art—was new in painting. The silkscreen technique itself challenged the traditional idea that the touch of the artist's own hand was essential to the act of creation, an act that produced one-of-a-kind masterpieces. It was this shift that quickly captured the attention of the art world and the public in the early 1960s. While some critics questioned whether the borrowing of imagery from popular culture and the use of mechanistic processes truly comprised cutting-edge fine art, the work of Warhol and others was rapidly recognized as a movement and dubbed "Pop art." Without delaying judgment, major museums and an expanding art-buying public welcomed this new kind of art. The pace of art history—like that of contemporary life—was speeding up.

Ironically, despite his assertions, Warhol did not actually attempt to make identical silkscreened images, which would be the goal of a commercial printer. We know that he enjoyed the drips and slips that might happen during silkscreening, as he left them behind in finished works. Moreover, when Andy made several canvases from the same screen, he often changed the arrangement and number of images from one work to the next and modified color schemes. His supposedly "easy" and "machinelike" process could be used to produce endless variations.

• • • •

Selecting the source material for his works was an essential element of Warhol's process. The medium of silkscreen capitalized on Warhol's habits as an obsessive collector. He had a variety of things stashed away—from magazine clippings and artworks to Fiestaware and cookie jars. He once wrote: "I like everything new but I hate to throw anything out."[8] Warhol devoted hours to perusing picture collections, such as the one at the New York Public Library, from which he "borrowed" images long beyond their due dates. He organized some of his photographs and clippings by subject in notebooks. He had a large collection of film stills and publicity pictures of Marilyn Monroe, among others. Visitors remarked upon the stacks of visual material covering the floor of one of his apartments.

That collecting habit was one aspect of Warhol's more general urge to document the world around him, which would appear in later years in his relentless recording—on photographic and movie film as well as on audiotape—of his circle of friends, acquaintances, and famous faces. In 1964, for example, he began filming the Screen Tests, three- to five-minute black-and-white silent films, with Malanga's assistance. As Andy's studio became the place to be and be seen in the mid-1960s, most visitors to the Factory were invited to sit for these portraits on film. Warhol made some five hundred of them in only a couple of years. Each visitor, whether famous or unknown, was in effect being given a chance to become a movie star, if only for a very short time. In addition, Warhol took an exorbitant number of photographs. Per one estimate, he made more than one hundred fifty thousand photographs in the last ten years of his life.[9] Andy's urge to collect images of the rich and famous and to elevate young unknowns to star status can be seen as an effort to grasp hold of fame for himself. Above all, Warhol's success in the art world, first as an illustrator and then as the pioneering "Prince of Pop," brought him admission into the realm of fashion and celebrity

Warhol's fixation on fame seems in part to be linked to longtime concerns about his appearance. Because of worries over hair loss, he first started wearing a naturally colored hairpiece around 1952. He chose a gray hairpiece

after the brown one to look both older and conspicuous. Metallic silver and various off-whites followed. Worried about the shape of his nose, his pores, and the uneven coloration of his skin, he had various medical procedures performed. Even if he could not change fixed physical attributes, he could change the image he presented to the world.

In his early years in New York, Warhol cultivated a deliberately disheveled look to add to his aura of naïveté. The presence of his mother and those cats added to the mystique, amusing the fashion-publishing types, according to his biographer Victor Bockris.[10] Warhol continued to fascinate as years went by, adapting his public presence at will. As David Bourdon has commented: "His metamorphosis into a pop persona was calculated and deliberate. The foppery was left behind as he gradually evolved from a sophisticate, who held subscription tickets to the Metropolitan Opera, into a sort of gum-chewing, seemingly naive teenybopper, addicted to the lowest forms of pop culture."[11] These ploys worked, and Warhol became known to the public as much through his skills at self-promotion as his artistic ingenuity.

Some who knew Warhol, including Henry Geldzahler, an art historian and curator, have viewed his creation of a public persona as a mask to hide behind. Geldzahler also described Andy's frenetic activity—the tape-recording and photographing, the zealous dedication to work—as an attempt to avoid introspection and self-examination.[12] "If you want to know all about Andy Warhol, just look at the surface of my paintings and films and me, and there I am. There's nothing behind it," the artist famously remarked.[13] By presenting only "surface" to the public and to friends, he may have been hiding his true self, but, as he did in his art, he was also making an ironic critique of the superficiality prevalent in contemporary American culture.

• • • •

Warhol made his first silkscreen portraits of celebrities in 1962. The series that he began in the early 1960s of Troy Donahue, Elizabeth Taylor, and Marilyn Monroe were based on publicity photographs that Andy selected and silkscreened in black on colored or silver backgrounds. He included brightly colored accents or variegated backgrounds in later versions. Begun in 1963, his images of Jackie Kennedy derive from news photographs taken before and after the President's assassination. The paintings memorialize a loss of innocence for America. In 1970 he started using his own photographs, taken with a Polaroid Big Shot camera, for the portraits. By the middle of the decade Andy had become a Pop art version of a society painter to the rich and famous, and the income from his portraits kept his film-making enterprise afloat. Assistants and art dealers obtained commissions for him. Attending parties and openings became an opportunity for Warhol to drum up more business. There was absolutely no distinction for Andy between work and play.

At the height of Warhol's popularity as a portraitist, new commissions ran from $25,000 to $35,000 for a forty-by-forty-inch canvas, his preferred format. Additional paintings made from the same screen came at a discounted price. While he was criticized by some in the art world for "cheapening" painting, the truth was Andy had never really drawn a line between commercial and fine art.[14] Indeed, he found success by walking the thin line between, and intermixing, the two, forever changing the way we see the world and interpret its profusion of consumer-targeted images. While shaping contemporary American culture, Warhol was simultaneously a product of that culture. As sculptor Carl Andre astutely observed after Andy's death in 1987: "Andy Warhol was the perfect glass and mirror of his age and certainly the artist we deserved."[15]

The treatment of sitters who were able to come to the Factory for a photography session

became a ritualized event for Warhol and members of his studio. (Warhol was equally happy to travel to his subjects.) Clients paid for the entire experience, which included lunch with invited guests at the studio. Andy would have his tape recorder on to catch the gossip. The lunch, according to Warhol's studio manager Vincent Fremont, was intended to help the client relax, so that Andy could get the best pictures.[16]

An elaborate makeup process to eliminate wrinkles and lighten up the skin tones followed. Warhol wanted details and lines in the face to disappear under his bright flash. The simpler the face, the more attractive the Polaroids and the final painting would be. Warhol then directed his sitter to take various poses, shooting, he reported, some five to ten rolls of film of each person. He, together with his client, selected the image for the silkscreen. He also asked the client for his or her color preferences as a means of flattery. However, when it came down to it, according to Fremont, Andy would make his own decision.[17]

After the client was sent home, the selected image was rephotographed with a thirty-five millimeter camera, enlarged, and printed as a positive on acetate. Andy often worked on the image at this stage to remove even more detail. This final image was then converted to a silkscreen stencil. A colored background on canvas could be prepared by an assistant in, say, half an hour. The photographic image was then silkscreened on top of the background. In some cases, additional paint was added by Warhol by hand to please the client.[18] Eyes, lips, and hair were often emphasized with bright color, particularly for women. Andy said this gave a "glossy, sexy look," although one is never quite sure when to take his words at face value.

For Warhol the key to his paintings lay in the photographic image rather than the person's actual appearance: "Beauties in photographs are different from beauties in person. It must be hard to be a model, because you'd want to be like the photograph of you, and you can't ever look that way. And so you start to copy the photograph."[19] As one writer has observed, in Warhol's paintings choreographer Martha Graham, who was well into her eighties when Andy photographed her, looks no older than singer Debbie Harry, some fifty years her junior (see pp. 51 and 53).[20]

While some critics were sure Warhol could produce another painting in minutes, Bourdon disagreed, stating in 1975, when Andy was actively engaged in commissions: "By the time he staples the canvas to the stretchers, he may have invested more time in producing his quasi-mechanical picture than a conventional portraitist spends on a canvas."[21] Whatever the total time invested or the minor imperfections that occurred during the silkscreening process, Warhol encouraged the impression that the portraits were mechanically produced, like the latest issue of *Life* magazine or a can of Del Monte peaches. Ironically, it was precisely Warhol's use of mass-printing techniques—halftone photo-reproduction and silkscreen—that distinguished his work as a fine artist. He carried this sense of commercialism into his self-promotion. In the case of the portraits, he encouraged buyers to purchase one for every room in the house. Warhol's marketing scheme worked, generating a steady stream of commissions.

Warhol had his finger on the pulse of contemporary culture. He set the age-old art of portraiture to the task of expressing an increasingly fast-paced environment replete with disposable images. His contention that anyone could become a star, if for only a short time, was aligned with a society in which novelty was used by manufacturers, film producers, and advertisers, among others, to attract a steady flow of repeat customers. Warhol could transform people into popular icons for public consumption. To Warhol consumerism was unequivocally democratic. The President of the United States and Liz Taylor drank Coke, and so could you.[22] Likewise, you, or anyone else, could become the next celebrity (if you weren't one already)

through Warhol's star treatment. It was Warhol who uniquely recognized that the egalitarianism of contemporary American culture was rooted in appearance, novelty, and conspicuous consumption. "Now it doesn't matter if you came over on the *Mayflower*, so long as you can get into Studio 54," he observed.[23]

The goal of his portraits, he claimed, was simply to make his subjects look beautiful. This took precedence over achieving likenesses or offering potential viewers of the canvases any particular insights into the sitters' personalities. Andy commented in 1983: "I try to make everybody look great. A few people give me a hard time about that. They say, 'Where's my big nose' or something like that, which I can't understand. But I put it back in if that's what they want."[24] However, if Andy had his way, your portrait would look so great that you would want to imitate it. Warhol could make anyone famous—for at least fifteen minutes.

Notes

1. Andy Warhol with Bob Colacello, *Andy Warhol's Exposures* (New York: Grosset & Dunlap, 1979), p. 50.

2. Robert Rosenblum, "Court Painter to the 70s," in Henry Geldzahler and Rosenblum, *Andy Warhol: Portraits of the Seventies and Eighties* (London: Anthony d'Offay Gallery in association with Thames and Hudson, 1993), p. 144.

3. Gene R. Swenson, "What Is Pop Art?" *Artnews* 62, no. 7 (Nov. 1963), p. 26.

4. David Bourdon, *Warhol* (New York: Harry N. Abrams, 1989), p. 31.

5. Nathan Gluck, who assisted Warhol on illustration, was paid into 1965. See Jesse Kornbluth, *Pre-Pop Warhol* (New York: Random House, 1988), p. 122.

6. *Andy Warhol*, 2nd ed. (Stockholm: Moderna Museet, 1969), unpag.

7. Ibid.

8. Warhol with Colacello, *Andy Warhol's Exposures*, p. 82.

9. Bob Colacello's estimate is cited in Christoph Heinrich, "Andy Warhol: Art Director—Amateur—Artist," in *Andy Warhol: Photography* (Pittsburgh: The Andy Warhol Museum; Hamburg: Hamburg Kunsthalle; Thalwil, Switzerland: Edition Stemmle, 1999), pp. 3 and 17.

10. Victor Bockris, *The Life and Death of Andy Warhol* (New York: Bantam Books, 1989), p. 67.

11. David Bourdon, "Andy Warhol 1928–87: A Collage of Appreciations from the Artist's Colleagues, Critics and Friends," *Art in America* 75, no. 5 (May 1987), p. 139.

12. Henry Geldzahler, "Andy Warhol: Virginal Voyeur," in Geldzahler and Rosenblum, *Andy Warhol*, p. 21.

13. *Andy Warhol*, 2nd ed., unpag.

14. Nicholas Baume, "About Face," in *About Face: Andy Warhol Portraits* (Hartford: Wadsworth Atheneum, 1999), p. 86.

15. Kynaston McShine, ed., *Andy Warhol: A Retrospective* (New York: The Museum of Modern Art, 1989), p. 436.

16. Vincent Fremont, "Andy Warhol's Portraits," in Geldzahler and Rosenblum, *Andy Warhol*, p. 33. In this text Fremont also describes the meal and Warhol's process.

17. Ibid., pp. 30–31.

18. Colored areas were often painted on the canvas before it was silkscreened. Warhol was not particularly worried about registration, and sometimes made the colored accents larger than they needed to be to align with the features. See Marco Livingstone, "Do It Yourself: Notes on Warhol's Techniques," in McShine, ed., *Andy Warhol*, pp. 70–75. However, new research hypothesizes that in silkscreen paintings from 1962–63 Warhol sandwiched the colored highlights between two layers of the main image silkscreened in black. See Georg Frei and Neil Printz, eds., *The Andy Warhol Catalogue Raisonné: Paintings and Sculpture 1961–1963* (London: Phaidon Press Limited, 2002), p. 468.

19. Andy Warhol, *The Philosophy of Andy Warhol (from A to B and Back Again)* (San Diego: Harcourt, 1977), p. 63.

20. John Smith, "Hollywood Stars and Noble Savages: Andy Warhol's Photography Collection," in *Andy Warhol: Photography*, p. 28.

21. David Bourdon, "Andy Warhol and the Society Icon," *Art in America* 63, no. 1 (Jan.–Feb. 1975), pp. 44–45.

22. Warhol, *The Philosophy of Andy Warhol*, pp. 100–01.

23. Warhol with Colacello, *Andy Warhol's Exposures*, p. 50.

24. Carter Ratcliff, *Andy Warhol* (New York: Abbeville Press, 1983), p. 114.

Robert Levin, *Andy Warhol*, c. 1981

Warhol, on the occasion of the "Movie Star Party" hosted by Dennis Hopper and Brooke Hayward to celebrate his 1963 exhibition in Los Angeles:

"Dean Stockwell, John Saxon, Robert Walker, Jr., Russ Tamblyn, Sal Mineo, Troy Donahue, and Suzanne Pleshette— everybody in Hollywood I'd wanted to meet was there.... This party was the most exciting thing that had ever happened to me."

TROY DONAHUE

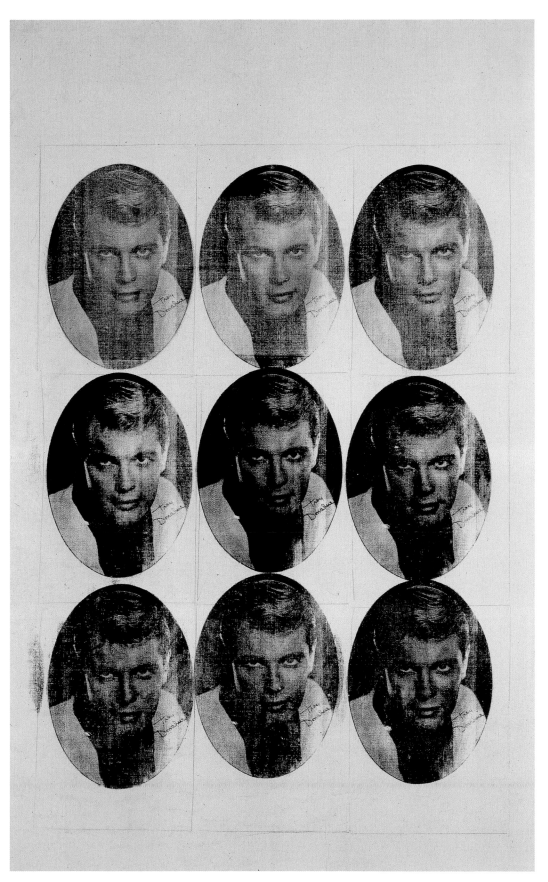

TROY 1962. SILKSCREEN INK AND PENCIL ON LINEN. 43¾ X 26"

MERCE CUNNINGHAM 1963. SILKSCREEN INK AND SPRAY PAINT ON LINEN. 35 ½ X 81½"

MERCE CUNNINGHAM

LIZ DIPTYCH (STUDIO TYPE) 1963. SILKSCREEN INK AND SPRAY PAINT ON LINEN. TWO PANELS, EACH 40 X 40"

ELIZABETH TAYLOR

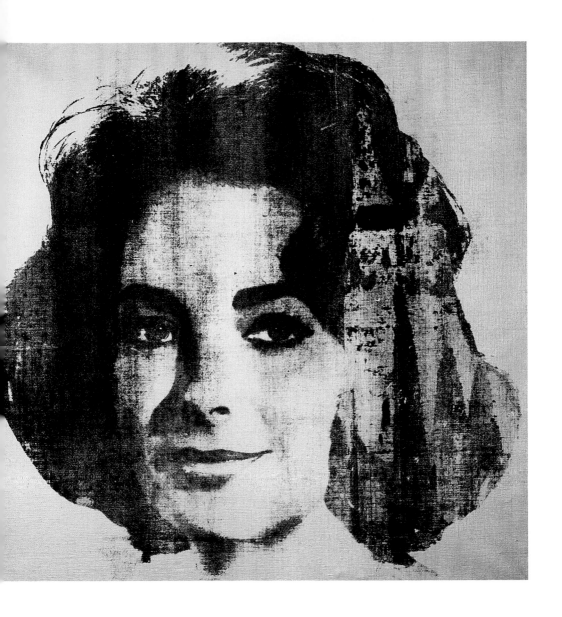

Warhol:

"I do like the idea of people turning into dust or sand, and it would be very glamorous to be reincarnated as a big ring on Elizabeth Taylor's finger."

"When I did my self-portrait, I left all the
pimples out because you always should.
Pimples are a temporary condition and they
don't have anything to do with what you really
look like. Always omit the blemishes—they're
not part of the good picture you want."

ANDY WARHOL

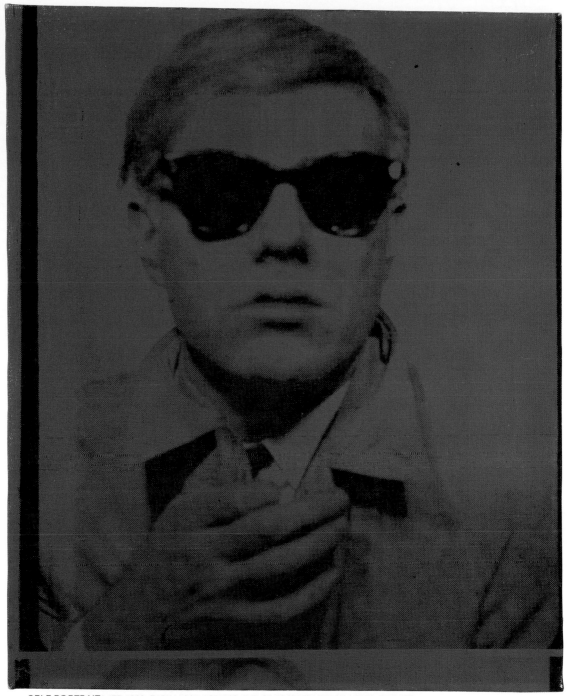

SELF-PORTRAIT LATE 1963–EARLY 1964. ACRYLIC AND SILKSCREEN INK ON LINEN. 20 X 16"

Warhol on Kennedy:

"Being with her is like walking with a saint."

JACQUELINE KENNEDY

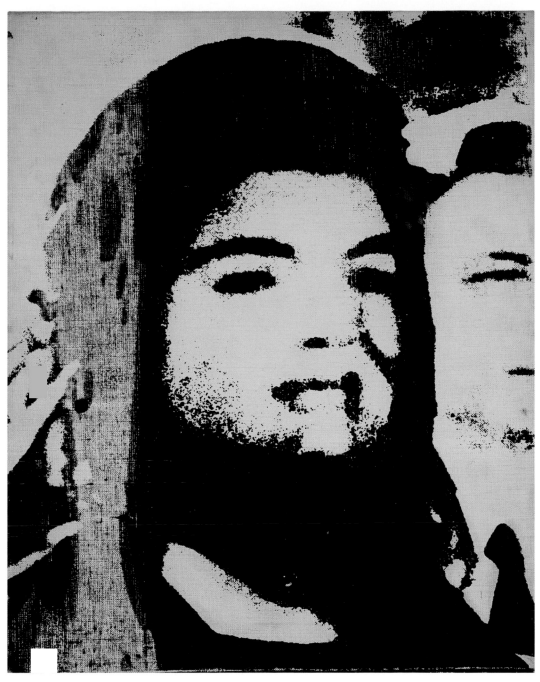

JACKIE 1964. ACRYLIC AND SILKSCREEN INK ON CANVAS. 20 X 16"

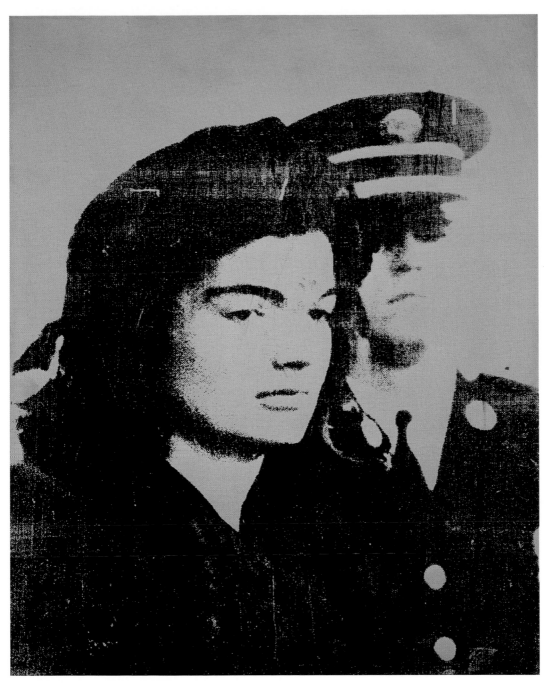

JACKIE 1964. ACRYLIC AND SILKSCREEN INK ON CANVAS. 20 X 16"

Warhol:

"We drove up to Lee's place on Fifth Avenue. Jackie and Lee were waiting in the lobby. They were wearing trenchcoats, just like any two normal women on their way to the museum in Brooklyn. Jackie wanted to know all about Elizabeth Taylor. I had just finished a two-week walk-on part in an Elizabeth Taylor vehicle called *The Driver's Seat*. It took two weeks because Elizabeth worked only an hour a day. . . . Jackie kept asking, 'What's Elizabeth Taylor really like?'"

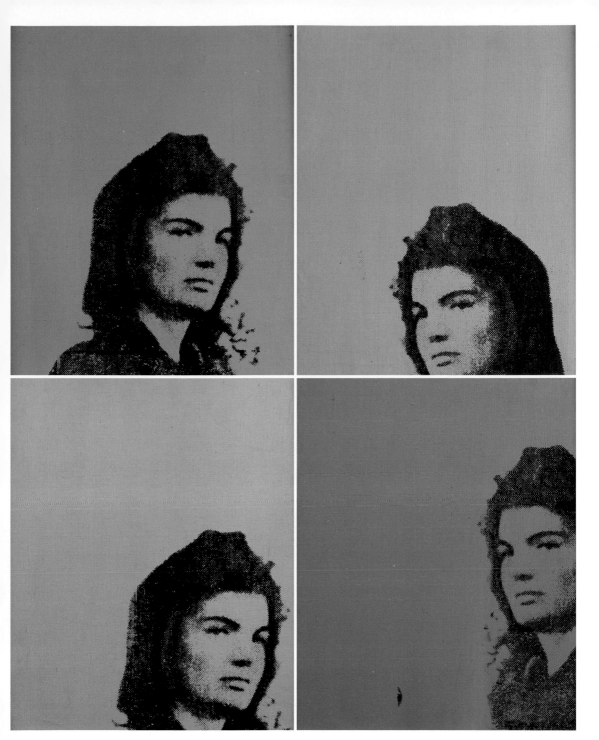

JACKIE 1964. ACRYLIC AND SILKSCREEN INK ON CANVAS. FOUR PANELS, EACH 20 X 16¾"

"Inspired by the publicity surrounding Marlon Brando's Stanley Kowalski in *A Streetcar Named Desire*, his uniform was chinos, T-shirts, and worn sneakers, and he carried his drawings in a brown paper bag."

MARLON BRANDO

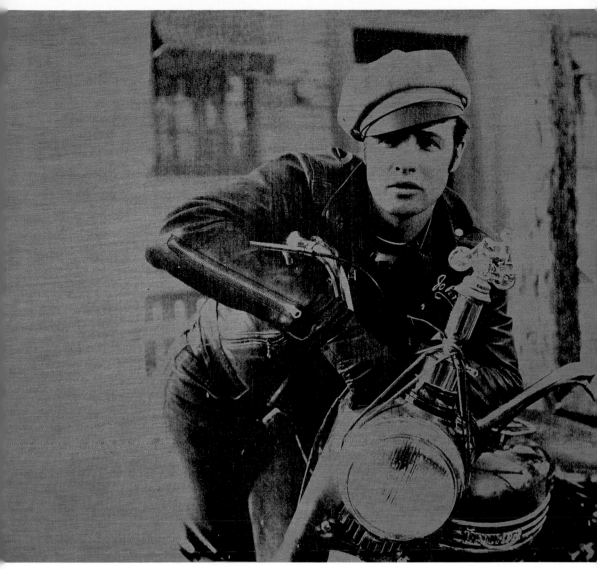

MARLON 1966. SILKSCREEN INK ON CANVAS. 41 X 46"

"I've never met a person I couldn't call a beauty. Every person has beauty at some point in their lifetime. Usually in different degrees. Sometimes they have the looks when they're a baby and they don't have it when they're grown up, but then they could get it back again when they're older."

ANDY WARHOL

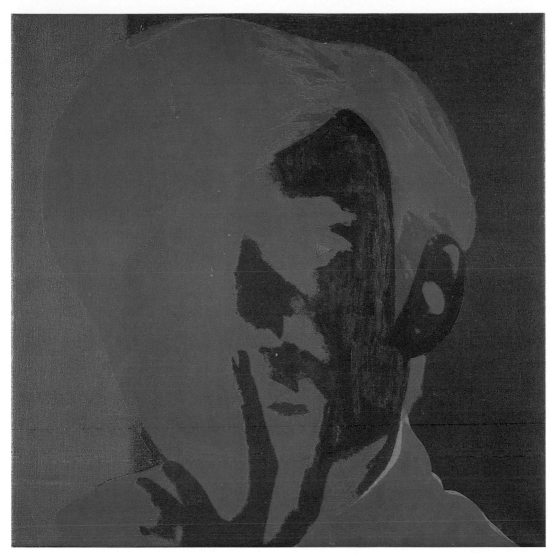

SELF-PORTRAIT 1966–67. ACRYLIC AND SILKSCREEN INK ON CANVAS. 22½ X 22½"

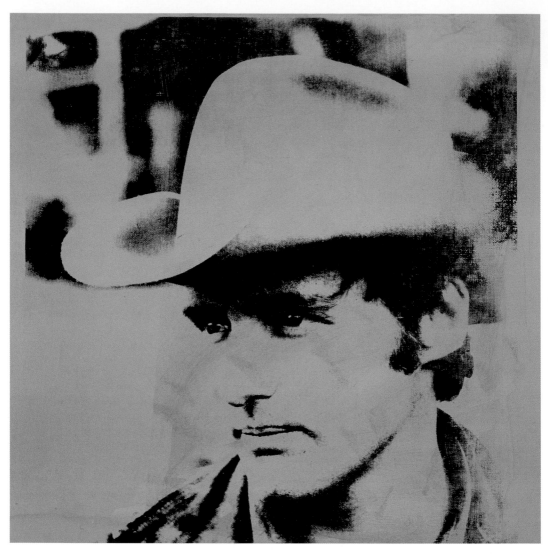

DENNIS HOPPER 1970. ACRYLIC AND SILKSCREEN INK ON CANVAS. 40 X 40"

Warhol on Hopper around 1961–63:

"Dennis wasn't getting much film work at this point; he was doing photography then. . . . I'd first seen him playing Billy the Kid on one of those Warner Brothers television westerns in the fifties . . . and I remember thinking how terrific he was, so crazy in the eyes. Billy the Maniac."

DENNIS HOPPER

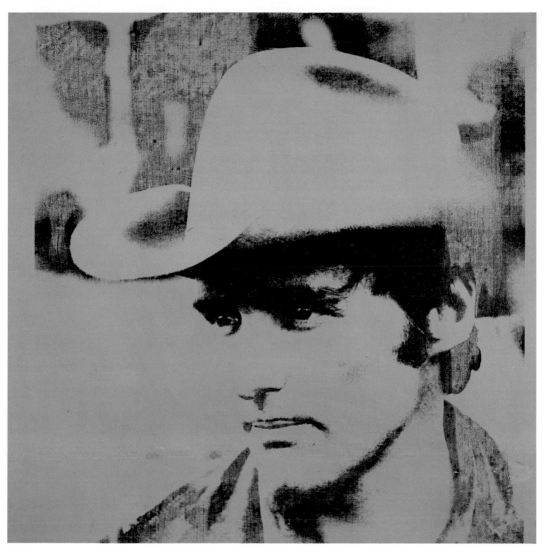

DENNIS HOPPER 1970. ACRYLIC AND SILKSCREEN INK ON CANVAS. 40 X 40"

Warhol on driving from New York to Los Angeles for his exhibition at Ferus Gallery in 1963:

"I knew the whole thing would be fun, especially since Dennis Hopper had promised us a 'Movie Star Party' when we got there."

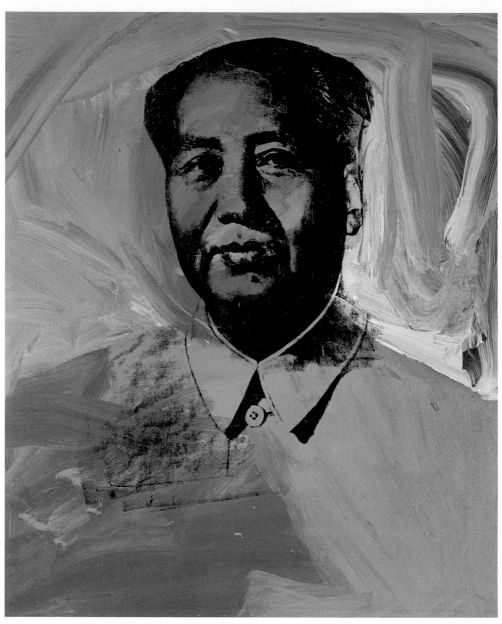

MAO 1973. ACRYLIC AND SILKSCREEN INK ON LINEN. 50 X 42"

MAO TSE-TUNG

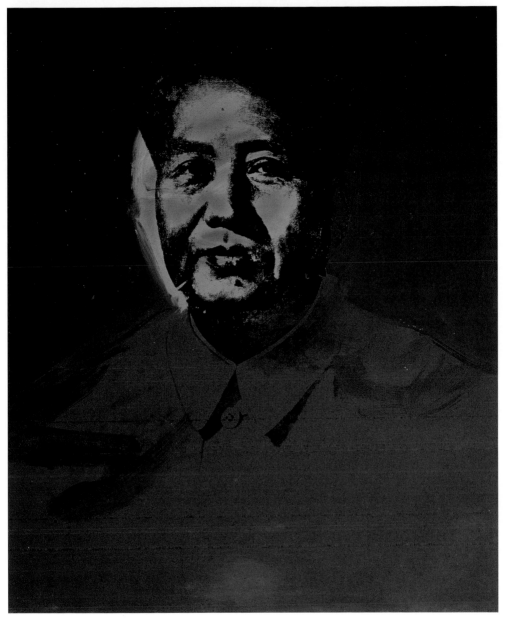

MAO 1973. ACRYLIC AND SILKSCREEN INK ON LINEN. 50 X 42"

Warhol to writer David Bourdon, 1971:

"Since fashion is art now and Chinese is in fashion, I could make a lot of money. **Mao would be really nutty. . . . Not to believe in it, it'd just be fashion . . .** but the same portrait you can buy in the poster store. Don't do anything creative, just print it up on canvas."

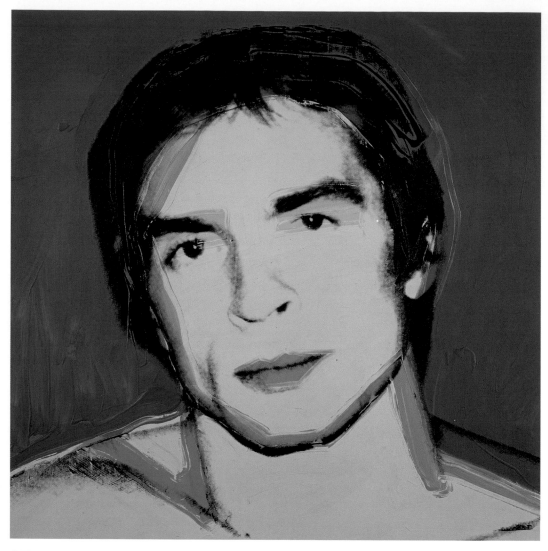

RUDOLPH NUREYEV C. 1975. ACRYLIC AND SILKSCREEN INK ON CANVAS. 40 X 40"

Warhol:

"It was also exciting meeting Nureyev. Monique had arranged for me to interview him, but I made a mistake and took Polaroids of him rehearsing. He ripped them up and threw them in my face. When I tried to pick up the pieces he stepped on my hand. I said it was exciting."

RUDOLPH NUREYEV

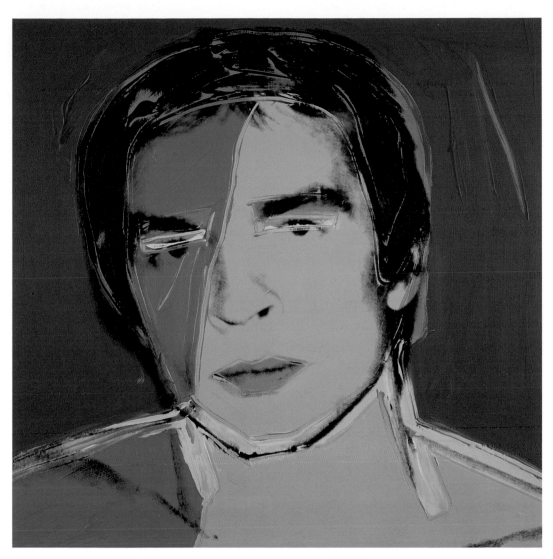

RUDOLPH NUREYEV C. 1975. ACRYLIC AND SILKSCREEN INK ON CANVAS. 40 X 40"

Warhol: How do you keep so skinny?

Jagger: Don't eat anything. I don't eat desserts or anything like that.
I do some exercise every day. . . .
What do you do Andy?

Warhol: I do 30 pushups now.

Jagger: Is that *all* you do? Then you'll only get *these* muscles.

Warhol: I never get any muscles.
I danced for the first time and that's new.

MICK JAGGER

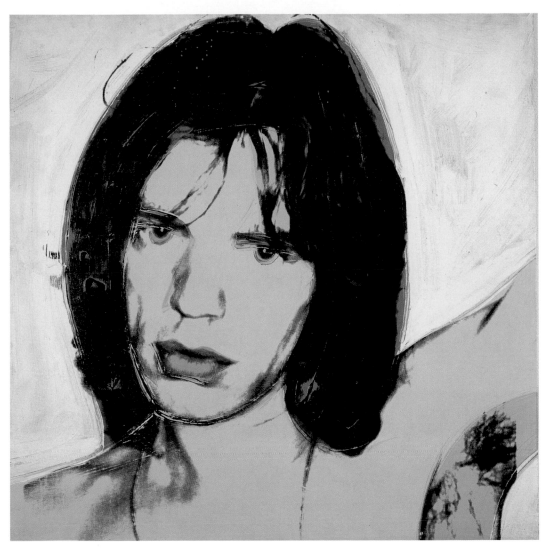

MICK JAGGER 1975–76. ACRYLIC AND SILKSCREEN INK ON CANVAS. 40 X 40"

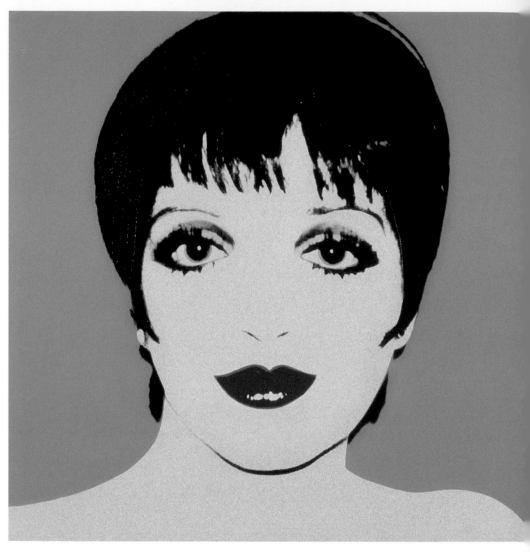

LIZA MINNELLI 1979. SYNTHETIC POLYMER PAINT AND SCREENPRINT ON CANVAS. TWO PANELS, EACH 40 X 40"
THE ANDY WARHOL MUSEUM, PITTSBURGH. FOUNDING COLLECTION. CONTRIBUTION DIA CENTER FOR THE ARTS

LIZA MINNELLI

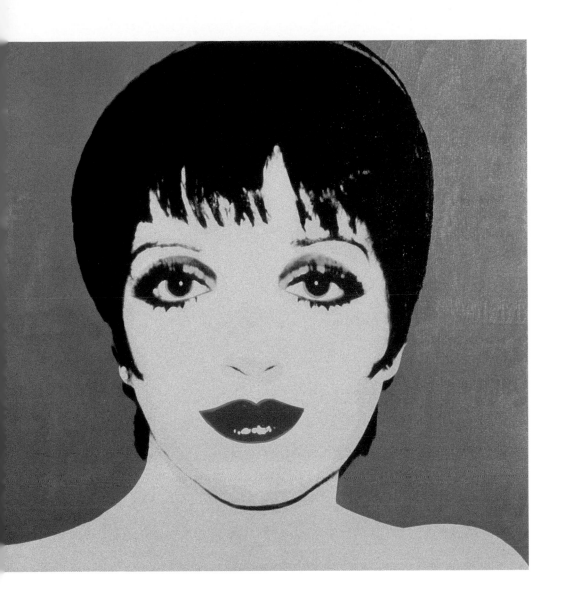

Warhol:

"Liza is always on and I'm always off. Liza has what Diana Vreeland calls 'built-in show biz.'"

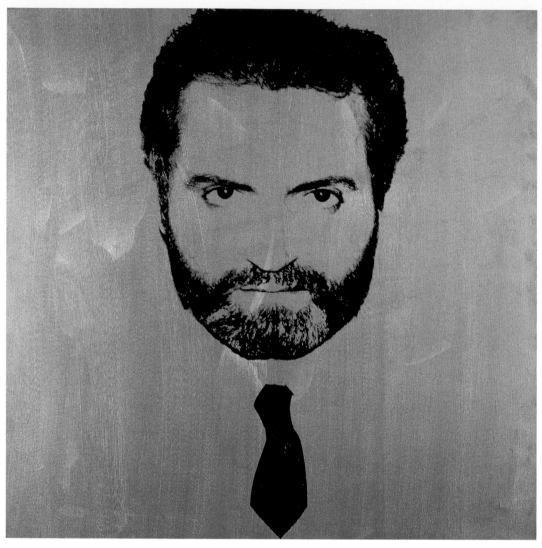

GIANNI VERSACE 1979–80. ACRYLIC AND SILKSCREEN INK ON CANVAS. 40 X 40"

GIANNI VERSACE

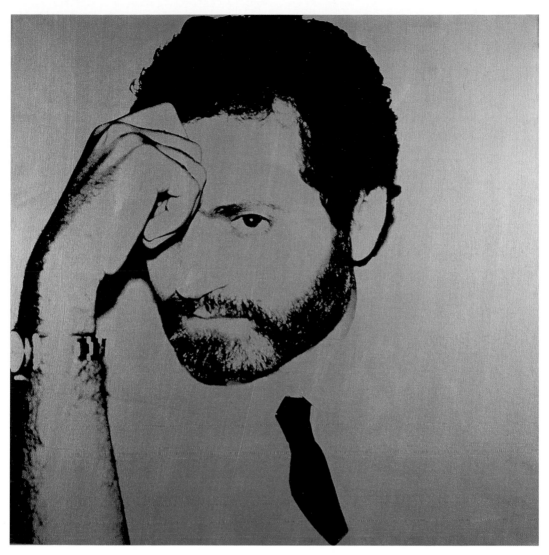

GIANNI VERSACE 1979–80. ACRYLIC AND SILKSCREEN INK ON CANVAS. 40 X 40"

"People look the most kissable when they're not wearing makeup. Marilyn's lips weren't kissable, but they were very photographable."

MARILYN MONROE

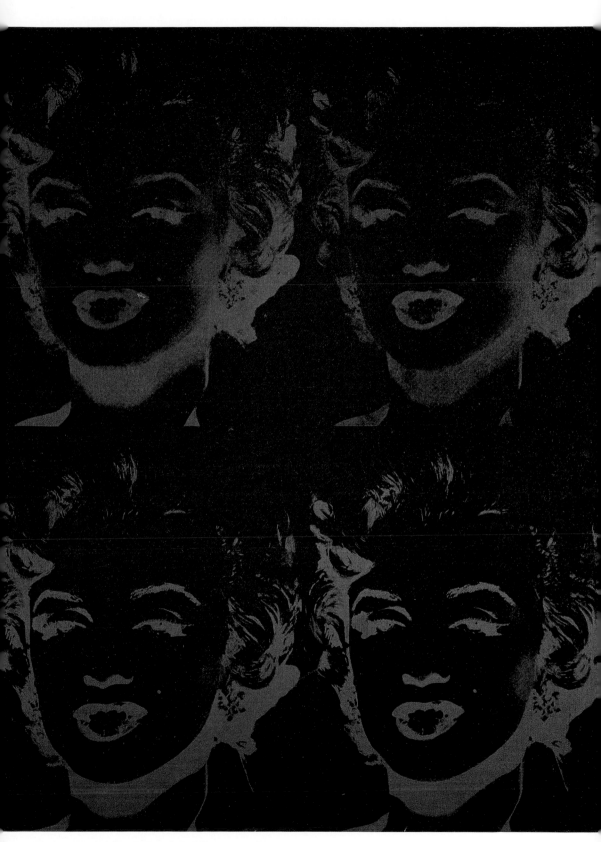

FOUR MARILYNS (REVERSAL SERIES) 1979–86. ACRYLIC AND SILKSCREEN INK ON CANVAS. 36 X 28"

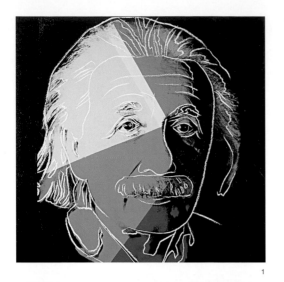

1

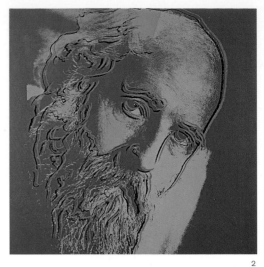

2

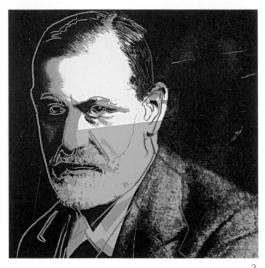

3

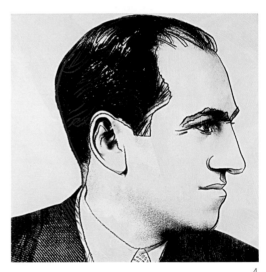

4

ALBERT EINSTEIN [1]

MARTIN BUBER [2]

SIGMUND FREUD [3]

GEORGE GERSHWIN [4]

LOUIS BRANDEIS [5]

SARAH BERNHARDT [6]

GERTRUDE STEIN [7]

GOLDA MEIR [8]

FRANZ KAFKA [9]

THE MARX BROTHERS [10]

TEN PORTRAITS OF JEWS OF THE TWENTIETH CENTURY
1980. ACRYLIC AND SILKSCREEN INK ON CANVAS. EACH 40 X 40"

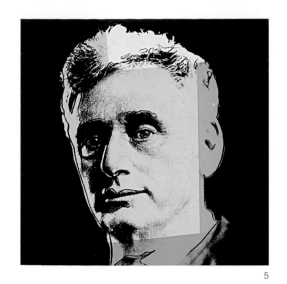

5

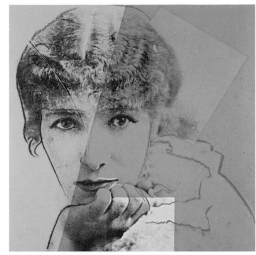

6

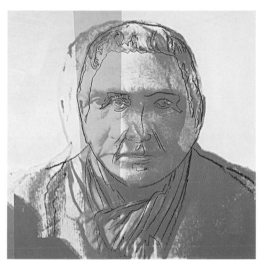

7

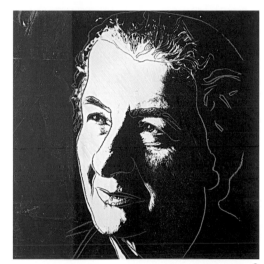

8

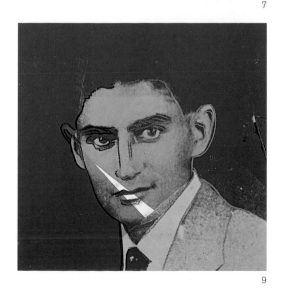

9

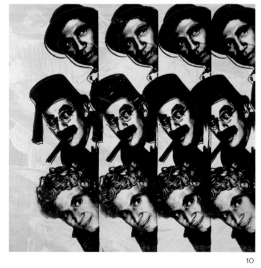

10

From Warhol's diary entry for October 24, 1985:

"Cabbed to the Palladium for Debbie Harry's party ($6) for her song that Jellybean produced, 'Feel the Spin.' When Debbie arrived, she saw us in the balcony and came up there because she thought it was the place to . . . be, and then it *was* the place to be because all the photographers came after *her*. She looks great. Debbie actually was the first Madonna."

DEBORAH HARRY

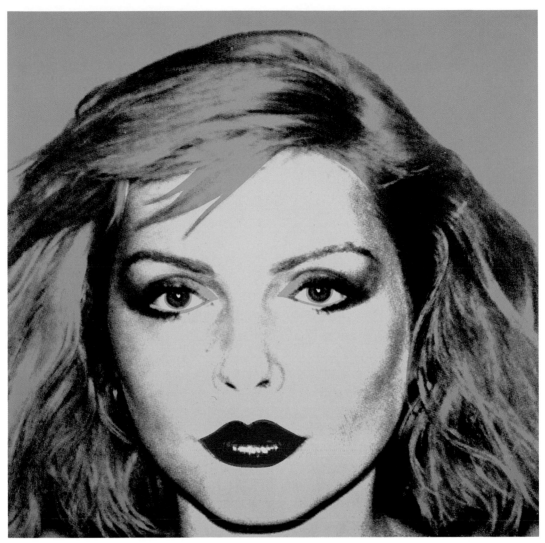

DEBBIE HARRY 1980. ACRYLIC AND SILKSCREEN INK ON CANVAS. 42 X 42"

"Halston picked me up and we went over to Martha Graham's studio on I think 63rd, to watch her rehearse. Martha arrived and she's so great, so young. She has a guy who looks after her. Then we went over to Halston's for dinner. Martha's going to England to do a command performance, and to Egypt, and to Lisbon. Her Iranian performance was cancelled, naturally, but I don't see how she can do it at her age, it's so hard, traveling like that. We talked about cosmetic surgery. I remember somebody telling me once that when Martha was down and out, a kind couple took her in and gave her a facelift and then her career revived."

MARTHA GRAHAM

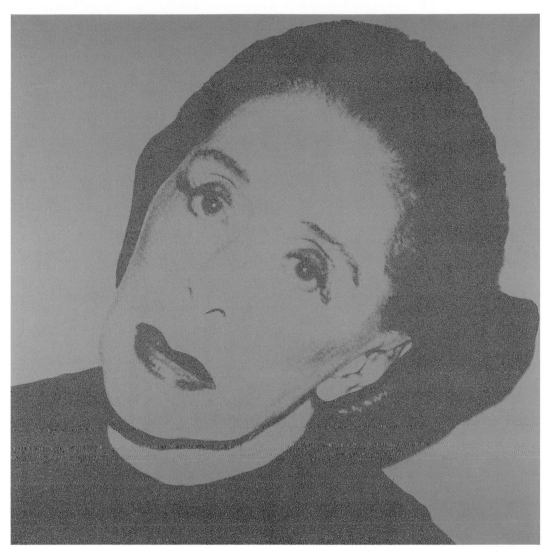

MARTHA GRAHAM 1980. ACRYLIC, SILKSCREEN INK, AND DIAMOND DUST ON CANVAS. 40 X 40"

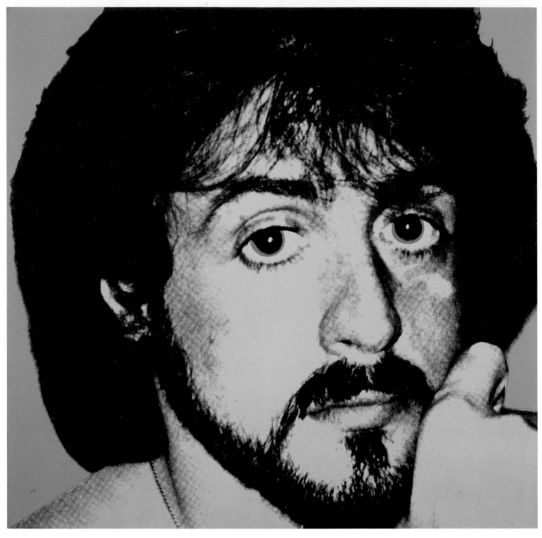

SYLVESTER STALLONE 1980. ACRYLIC AND SILKSCREEN INK ON CANVAS. 40 X 40"

From Warhol's diary entry for July 12, 1980 (written in Monte Carlo):

"Ran into Sylvester Stallone who cut his beard and looks great, . . . and I told him I wanted to do his portrait over again without the beard because he looks so handsome. And so he was going to come up about 6:00 so I could

SYLVESTER STALLONE

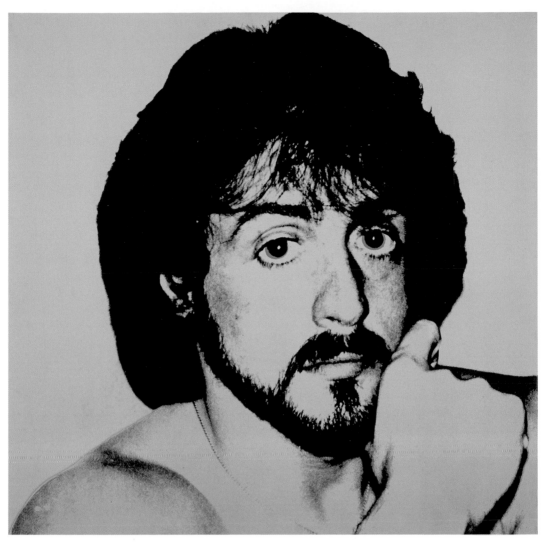

SYLVESTER STALLONE 1980. ACRYLIC AND SILKSCREEN INK ON CANVAS. 40 X 40"

rephotograph him. Then I ran into him again, on the beach, and all the people on the beach were taking pictures of him. He looked so great without clothes on, he's pencil-thin, he looks like a muscle man, like Mr. America with small biceps, and I told him not to ever put any more weight on again. But he was saying he had to because he had to do *Rocky III* and so I told him to do a fat suit."

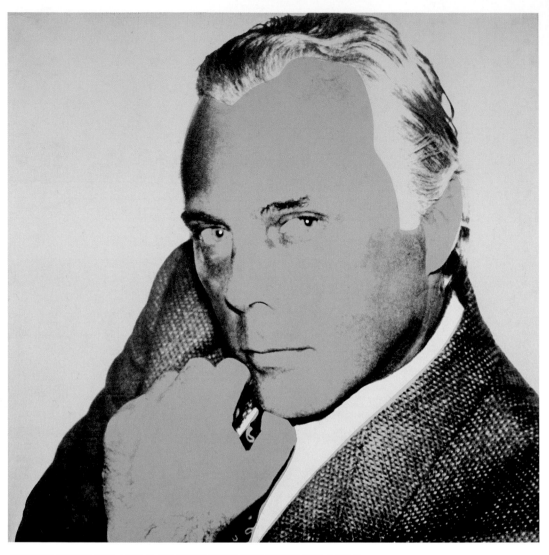

GIORGIO ARMANI 1981. ACRYLIC AND SILKSCREEN INK ON CANVAS. 39 $^{3}/_{4}$ X 39 $^{3}/_{4}$"

GIORGIO ARMANI

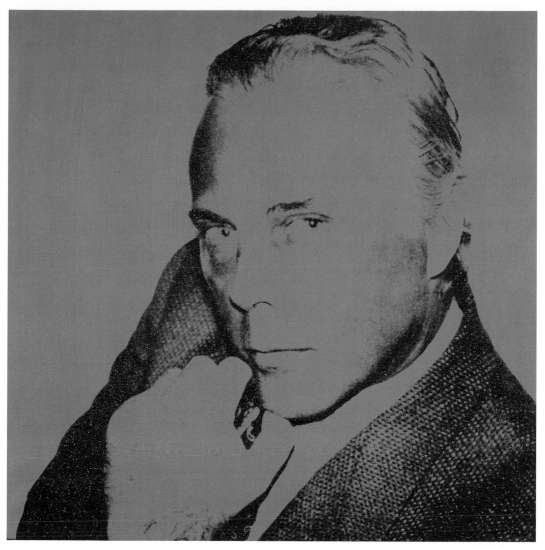

GIORGIO ARMANI 1981. ACRYLIC, SILKSCREEN INK, AND DIAMOND DUST ON CANVAS. 39 $^3/_4$ X 39 $^3/_4$"

"Andy always idolized Walt Disney. Andy wanted to be like Walt Disney. In other words, the entrepreneur. . . . In fact, when Andy and I went to California, we went to Disneyland. It was definitely a *must* on our itinerary."

MICKEY MOUSE

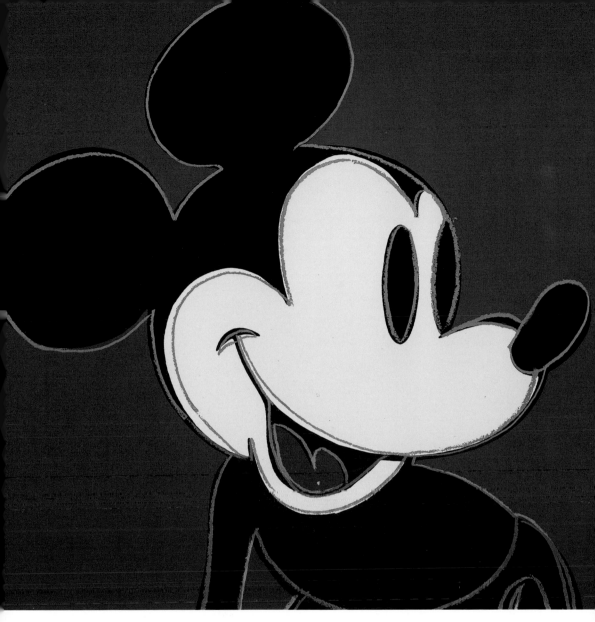

MICKEY MOUSE (MYTHS SERIES) 1981. ACRYLIC AND SILKSCREEN INK ON CANVAS. 60 X 60"

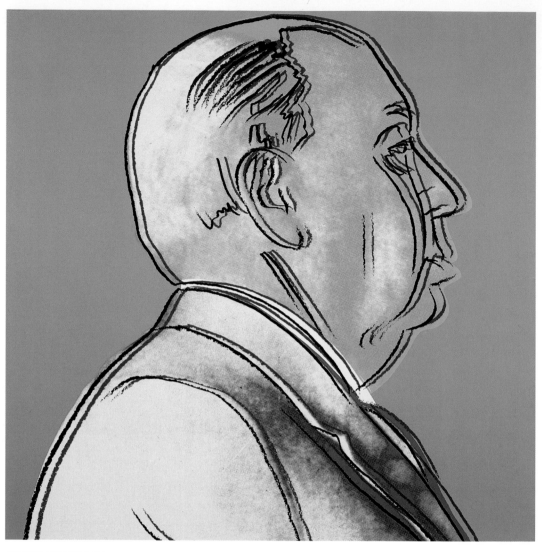

ALFRED HITCHCOCK 1983. ACRYLIC AND SILKSCREEN INK ON CANVAS. 40 X 40"

Warhol and Hitchcock in conversation, 1974:

Warhol: Maybe you can streak in your next film.

Hitchcock: Streak. Yes. I'll look pretty streaking.

ALFRED HITCHCOCK

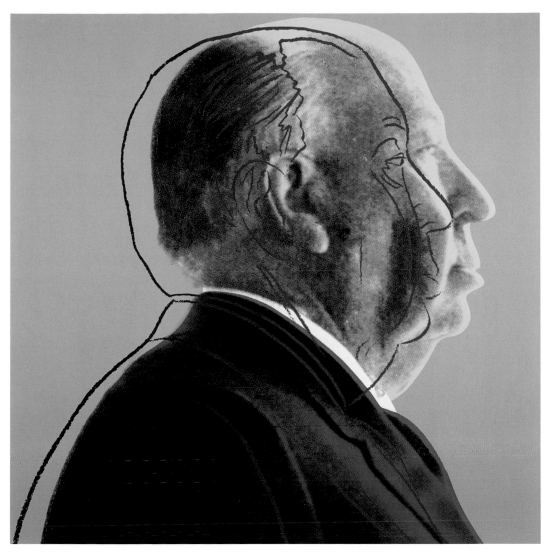

ALFRED HITCHCOCK 1983. ACRYLIC AND SILKSCREEN INK ON CANVAS. 40 X 40"

Warhol and Hitchcock in conversation, 1974:

Warhol: Well I was shot by a gun, and it just seems like a movie. I can't see it as being anything real. The whole thing is still like a movie to me. It happened to me, but it's like watching tv. If you're watching tv, it's the same as having it done to yourself.

Hitchcock: Yes. Yes.

Warhol: So I always think that people who do it must feel the same way.

Hitchcock: Well a lot of it's done on the spur of the moment. You know . . .

Warhol: Well if you do it once, then you can do it again, and if you keep doing it, I guess it's just something to do . . .

Hitchcock: Well it depends whether you've disposed of the first body. That is a slight problem. After you've committed your first murder.

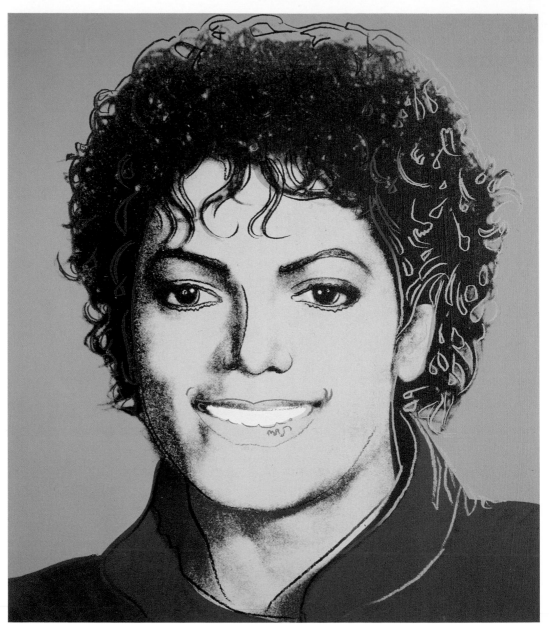

MICHAEL JACKSON 1984. ACRYLIC AND SILKSCREEN INK ON CANVAS. 30 X 26"

MICHAEL JACKSON

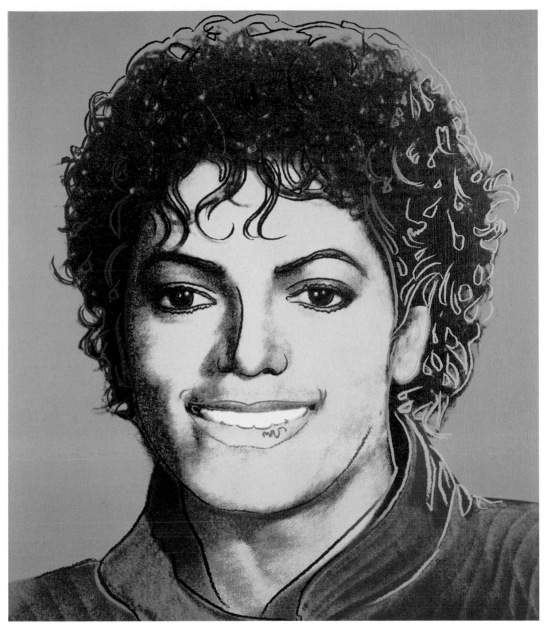

MICHAEL JACKSON 1984. ACRYLIC AND SILKSCREEN INK ON CANVAS. 30 X 26"

Warhol and Jackson in conversation, 1977:

Jackson: Do you like to draw?

Warhol: Do I like to draw?

Jackson: Do you like art?

Warhol: Ahh . . . I'd really like to make movies but they're harder to do.

Jackson: I always thought you were a poet.

Warhol: A poet? A poet usually writes good music but I can't even sing. . . .

Jackson: You know who I always see you with? I don't know why but when I usually see a picture of you you're usually with Alfred Hitchcock. I thought you were brothers or something.

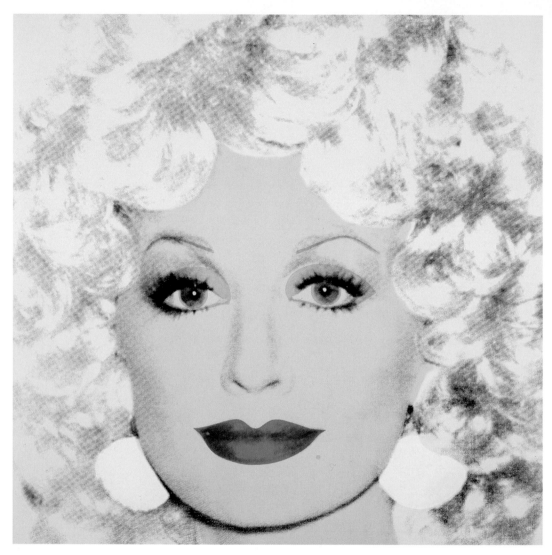

DOLLY PARTON 1985. ACRYLIC AND SILKSCREEN INK ON CANVAS. 42 X 42"

Warhol and Parton in conversation, 1984:

Parton: When I was a freshman in high school, hair teasing came out. I'd already bleached my hair and got in big trouble. I have blonde hair, but it just wasn't radiant, it's sandy

DOLLY PARTON

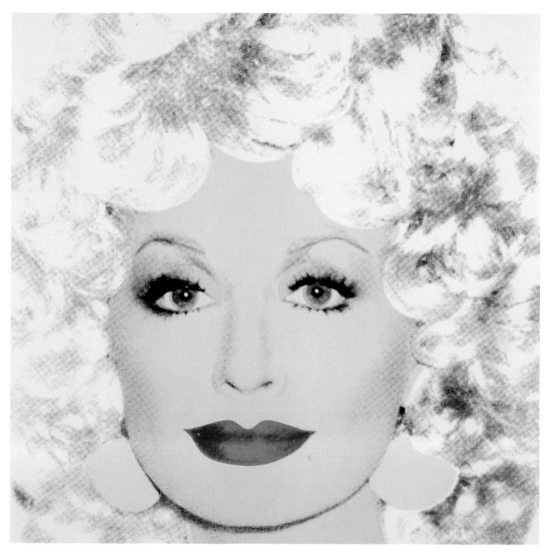

DOLLY PARTON 1985. ACRYLIC AND SILKSCREEN INK ON CANVAS. 42 X 42"

and bright. When teasing came out I just thought I had died and gone to heaven. Being creative with my hands, I started teasing. I fixed everybody's hair. I had the biggest hair in school. I had lots of teachers that had a hard time dealing with me because I felt sexy.

Warhol: You have the smallest waistline.

Parton: That was always one of my best assets.

Warhol and Parton in conversation, 1984:

Warhol: You could be a great preacher.

Parton: What do you mean? I *am* a great preacher.

Warhol:

"Then the doorbell rang. . . .
Who should come walking
through the bullet-proof door
but John Lennon, in a pea
jacket and a wool cap. . . . Liza
screeched, 'John Lennon! I've
never met him! Where is he?'

It's really great to be there when two big
stars collide, especially if you have your
camera and your tape recorder.

They looked so adorable
together. They should do a
show together. I'd love to
produce it."

JOHN LENNON

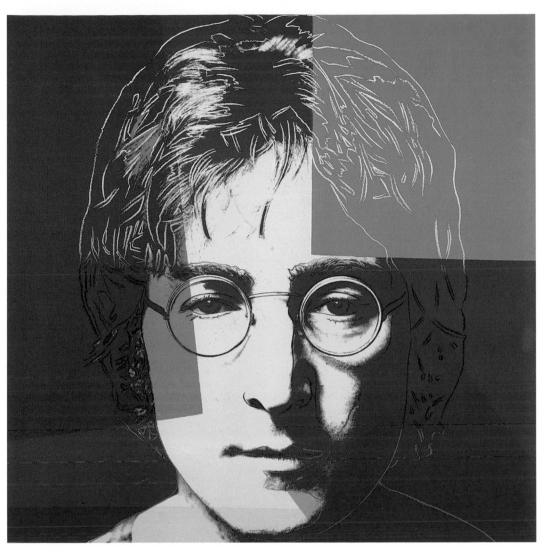

JOHN LENNON 1985–86. ACRYLIC AND SILKSCREEN INK ON CANVAS. 40 X 40"

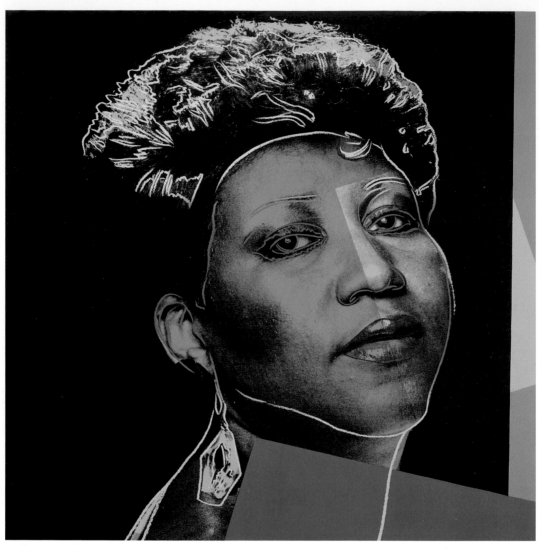

ARETHA FRANKLIN C. 1986. ACRYLIC AND SILKSCREEN INK ON CANVAS. 40 X 40"

ARETHA FRANKLIN

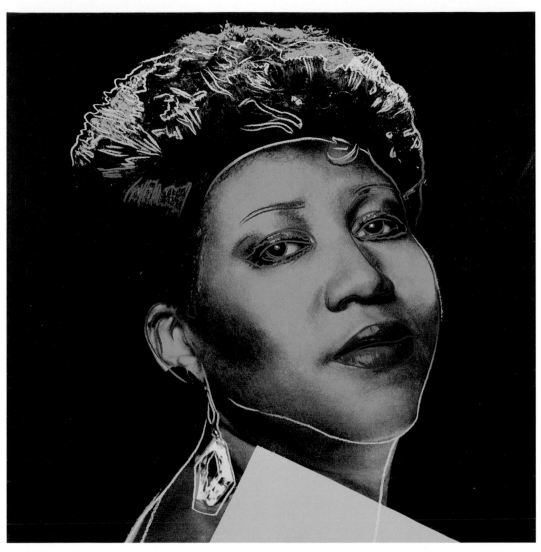

ARETHA FRANKLIN C. 1986. ACRYLIC AND SILKSCREEN INK ON CANVAS. 40 X 40"

"If you want to know all about Andy Warhol, just look at the surface of my paintings and films and me, and there I am. There's nothing behind it."

ANDY WARHOL

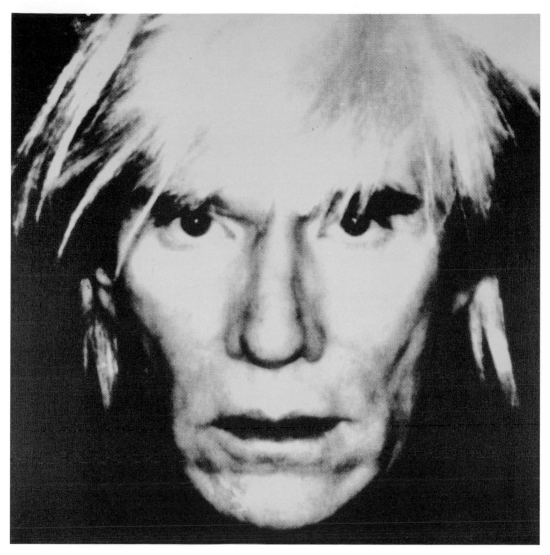

SELF-PORTRAIT 1986. ACRYLIC AND SILKSCREEN INK ON CANVAS. 40 X 40"

Photograph Credits

Photographs of all Warhol's works except for *Liza Minnelli* were provided by the Mugrabi Collection. Additional credits follow:

pp. 6–7: Twin Images/Timepix

p. 10: © Duane Michals, courtesy Pace/MacGill Gallery, New York

p. 15: © 2003 Robert Levin/Corbis

p. 25: Source image: photograph by Henri Dauman, 1963

p. 29: Photo by Kevin Ryan

pp. 44–45: Photos by Phillips/Schwab

pp. 48, 49, and 59: © 2003 Ronald Feldman Fine Arts, New York

Sources for Quotes

Endpaper: *Andy Warhol*, 2nd ed. (Stockholm: Moderna Museet, 1969), unpag.

p. 16: Andy Warhol and Pat Hackett, *Popism: The Warhol Sixties* (San Diego: Harcourt Brace & Company, 1980), pp. 41–42.

p. 21: "Brush with Fame," *Entertainment Weekly*, nos. 583–84 (Feb. 23, 2001), p. 168.

p. 22: Andy Warhol, *The Philosophy of Andy Warhol (from A to B and Back Again)* (San Diego: Harcourt, 1977), p. 62.

p. 24: Andy Warhol with Bob Colacello, *Andy Warhol's Exposures* (New York: Grosset & Dunlap, 1979), p. 82.

p. 28: Warhol with Colacello, *Andy Warhol's Exposures*, p. 81.

p. 30: Victor Bockris, *The Life and Death of Andy Warhol* (New York: Bantam Books, 1989), p. 52.

p. 32: Warhol, *The Philosophy of Andy Warhol*, p. 61.

p. 34: Warhol and Hackett, *Popism*, p. 41.

p. 35: Warhol and Hackett, *Popism*, p. 36.

p. 37: David Bourdon, *Warhol* (New York: Harry N. Abrams, 1989), p. 317.

p. 38: Warhol with Colacello, *Andy Warhol's Exposures*, p. 176.

p. 40: Originally published in *INTERVIEW* Magazine, Aug. 1981, p. 26. Reprinted by permission of Brant Publications, Inc.

p. 43: Warhol with Colacello, *Andy Warhol's Exposures*, p. 186.

p. 46: Warhol, *The Philosophy of Andy Warhol*, p. 54.

p. 50: Andy Warhol, *The Andy Warhol Diaries*, ed. Pat Hackett (New York: Warner Books, 1989), p. 687.

p. 52: Warhol, *The Andy Warhol Diaries*, p. 213.

pp. 54–55: Warhol, *The Andy Warhol Diaries*, p. 302.

p. 58: Patrick S. Smith, *Warhol: Conversations about the Artist* (Ann Arbor: UMI Research Press, 1988), p. 171.

pp. 60–61: Originally published in *INTERVIEW* Magazine, Sept. 1974, pp. 7–8. Reprinted by permission of Brant Publications, Inc.

p. 63: Originally published in *INTERVIEW* Magazine, March 1977, p. 16. Reprinted by permission of Brant Publications, Inc.

pp. 64–65: Originally published in *INTERVIEW* Magazine, July 1984, pp. 34 and 36. Reprinted by permission of Brant Publications, Inc.

p. 66: Warhol with Colacello, *Andy Warhol's Exposures*, pp. 186–87.

p. 70: *Andy Warhol*, 2nd ed., unpag.